Do You Like Cunt Face?

Beautiful Swear Word To Color

For Stress Releasing

Chase C. Demon

Happy Coloring!

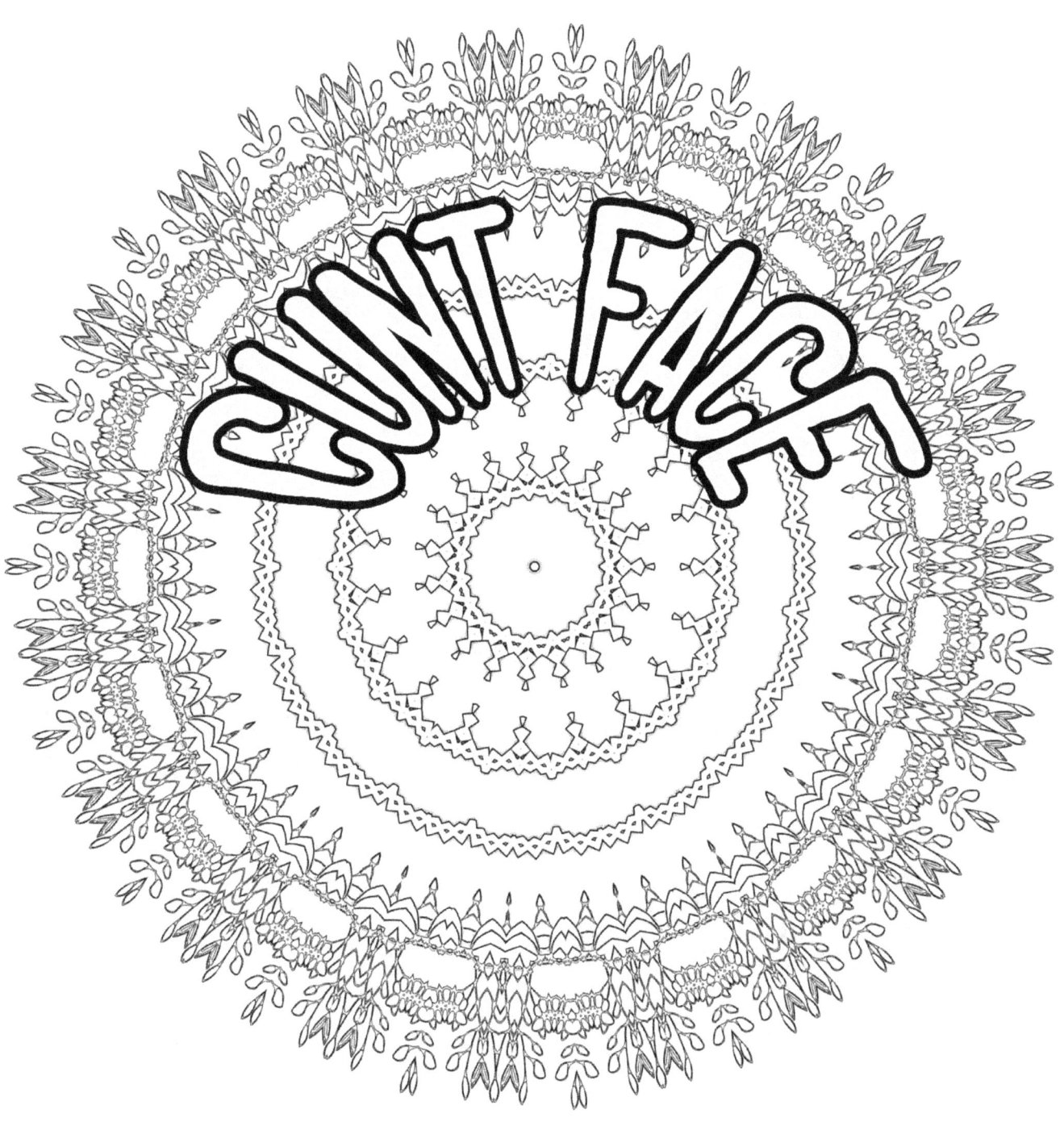

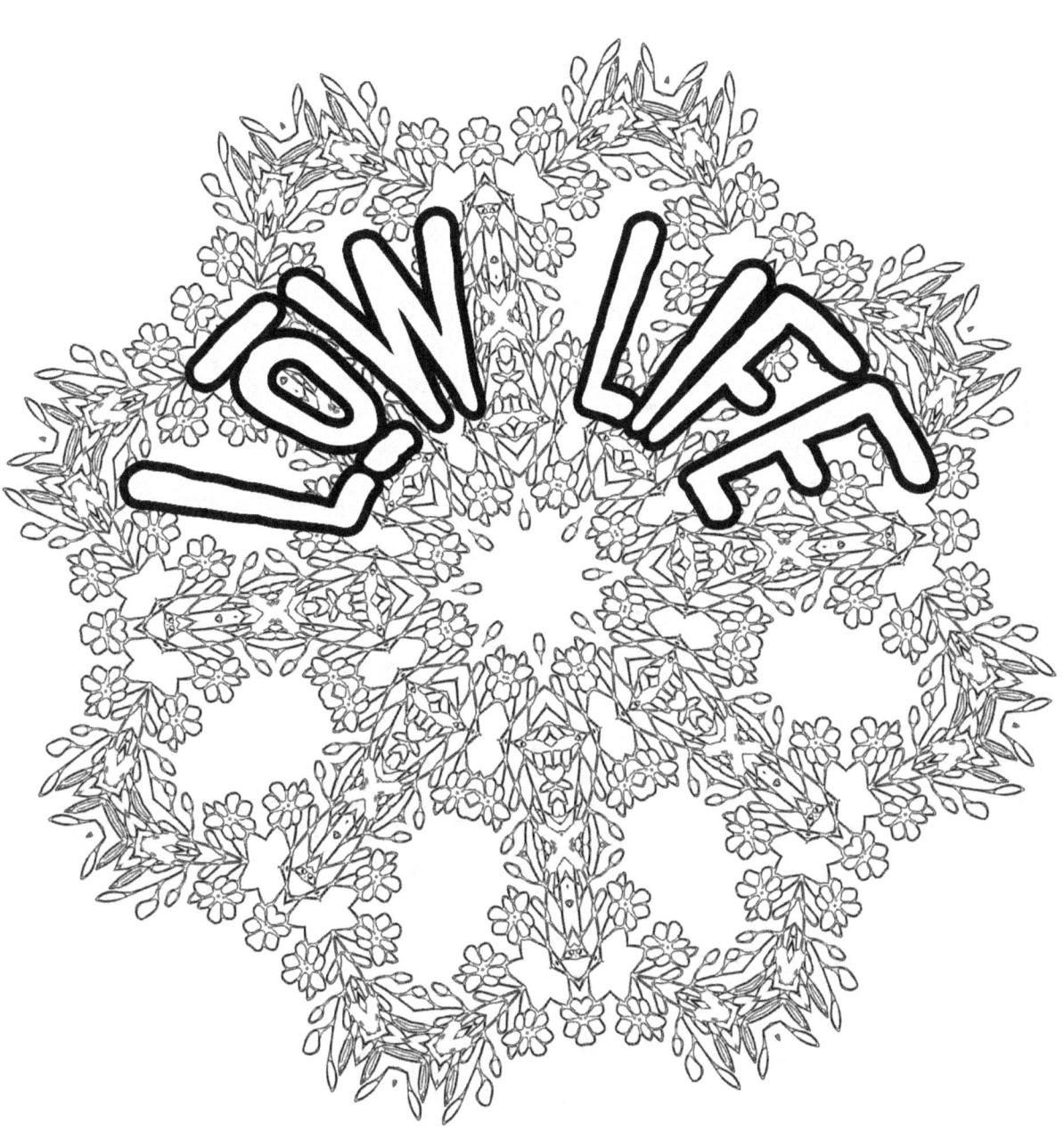

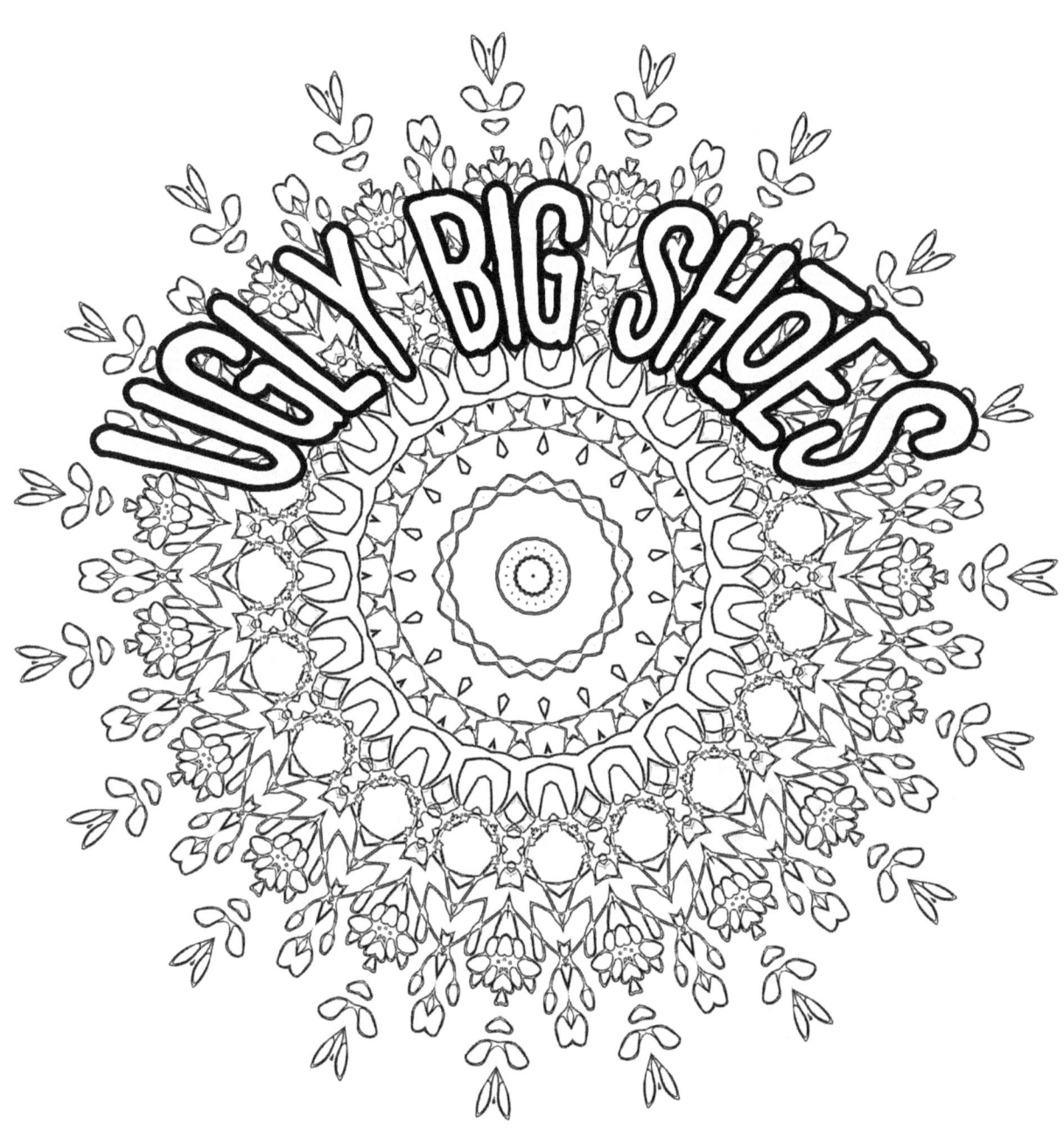

BASTARD

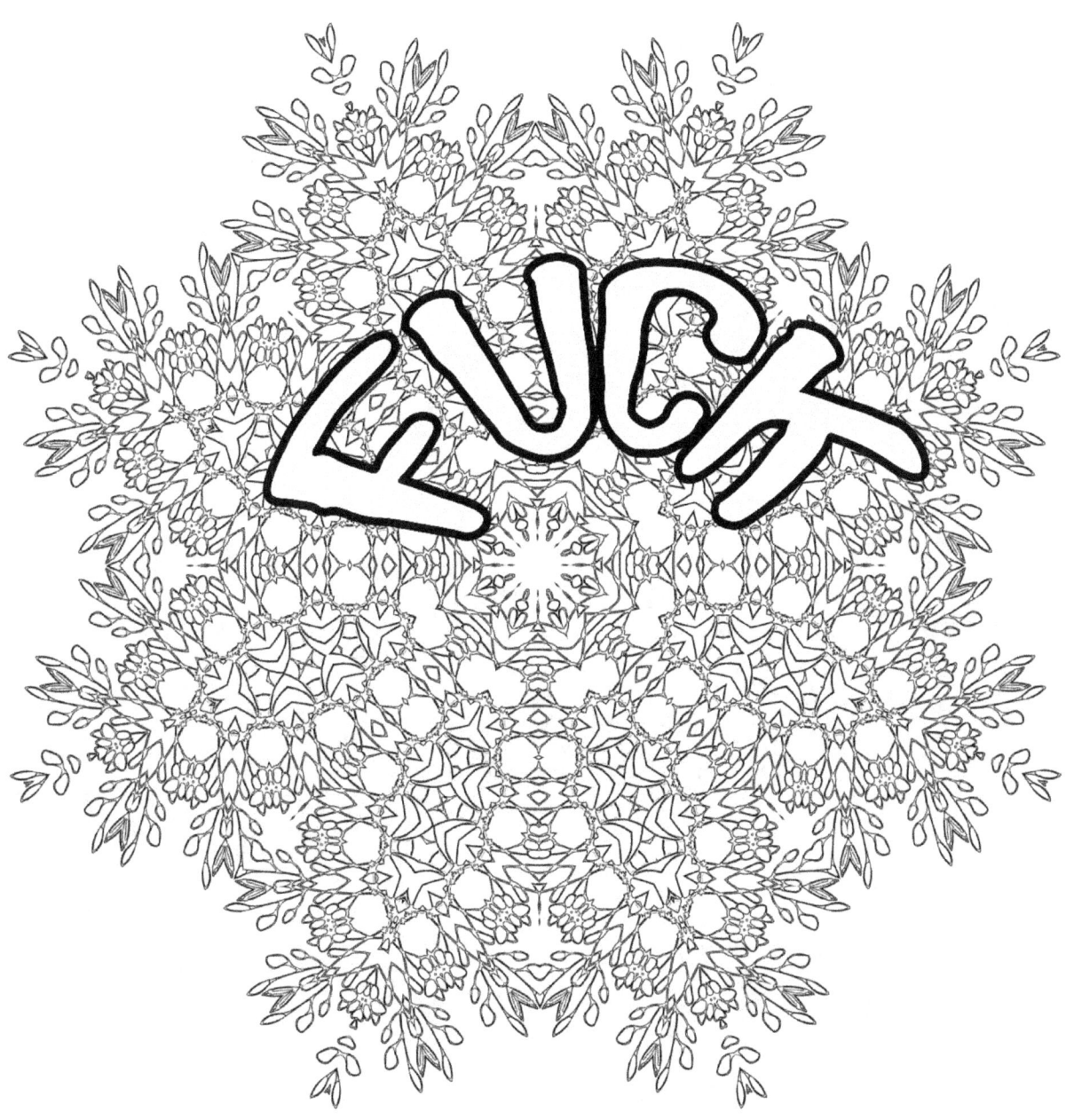

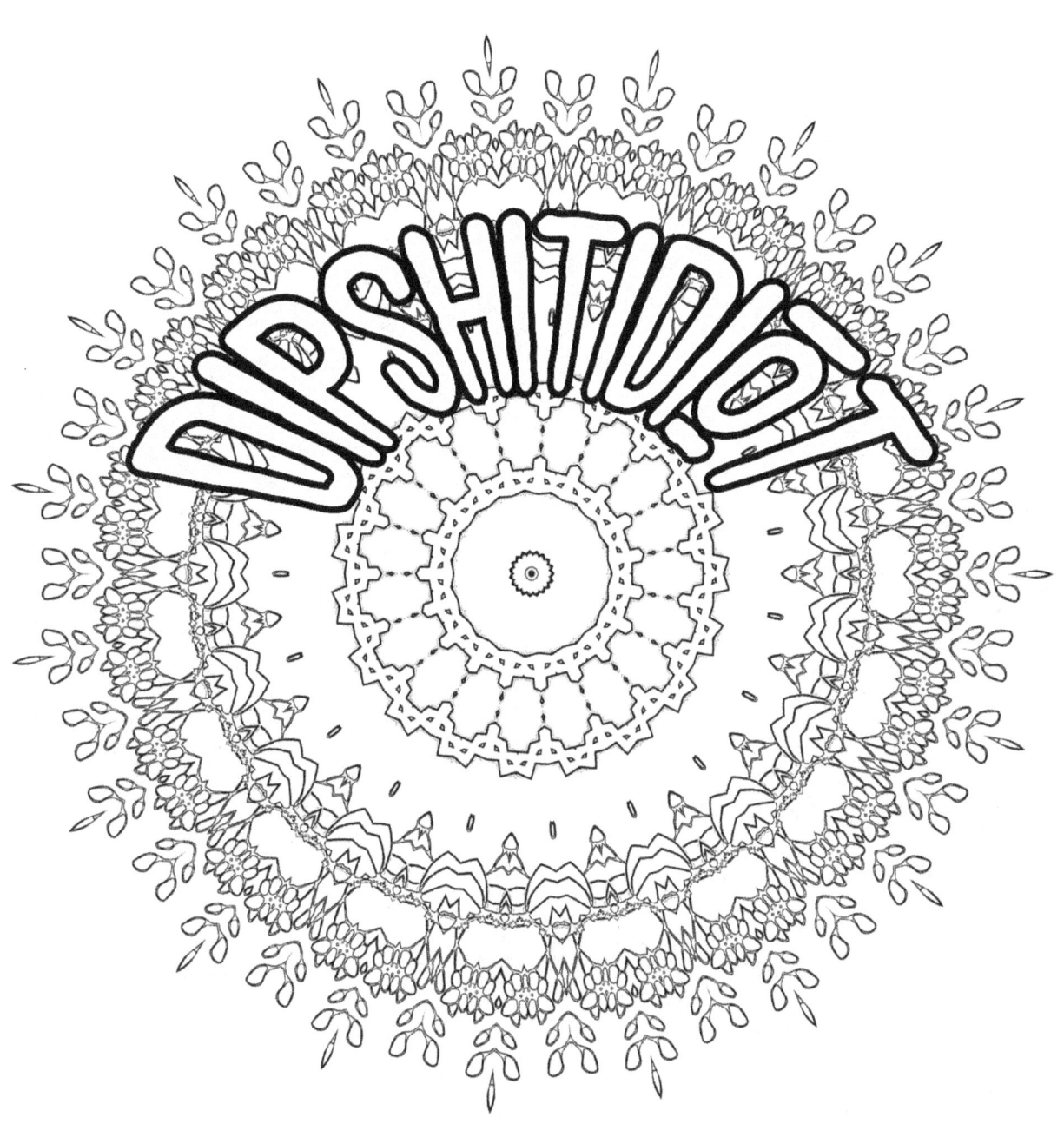

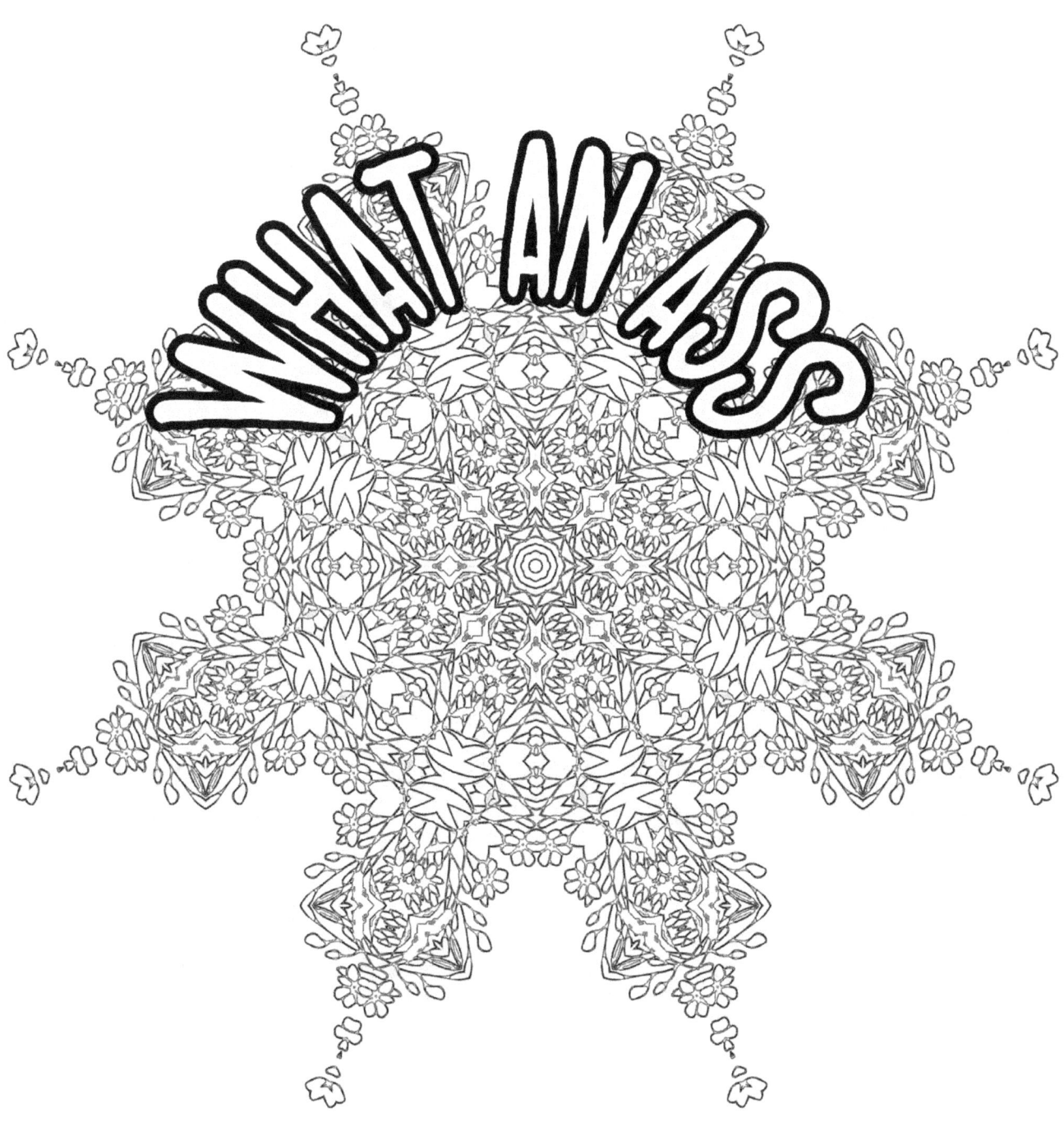

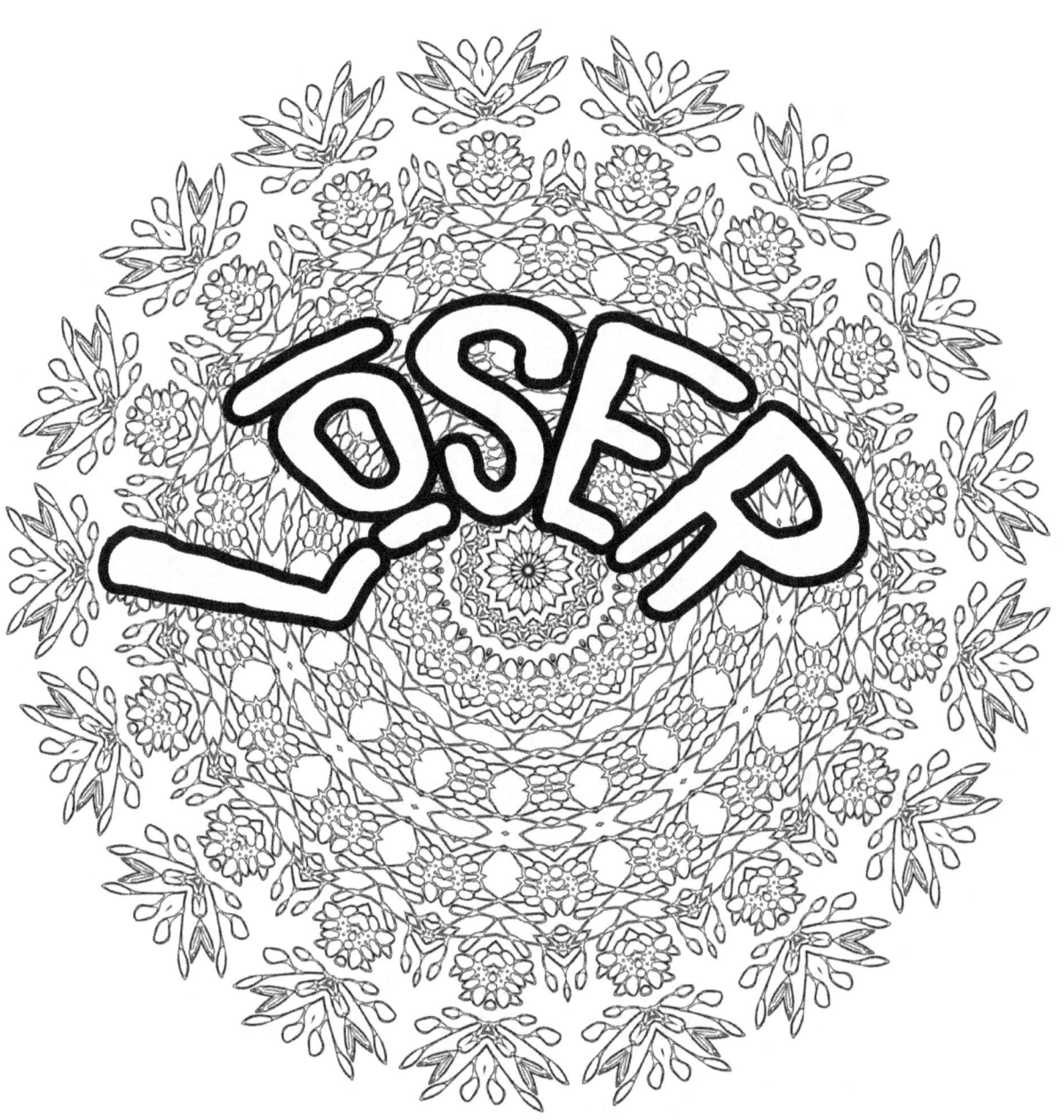

www.ingramcontent.com/pod-product-compliance
Lightning Source LLC
Chambersburg PA
CBHW081131180526

45170CB00008B/3066